My Favorite Color Is Rainbow!

**A collection of Nature, Weather, & Seasonal
Poem & Photographs**

By

Teresa Waters Author

Certificate of Registration Number TX 2-338-952 effective

date of registration: September 24,2022.

B0C2RTBS7J

TABLE Of CONTENTS

Cloud Coverlets poem

Cloud photo

El Valle Escondido

Photo od patriotic heart

Letter to Raymond

Photo of Torrey Pines

Photo of sunflowers

Photo of green tree

Intro to Melvin Floyd

Hailey Day in Ft. Sumner

+ 4 lines of Hailey poem

Photo of Great Arboreal

I live on a hill [English] and Vivo en una Loma [Spanish]

Photo of Hill

Intro to Islas and poem of Islas

Photo of palms + 4 lines of Islands poem

I walk in Beauty poem

Photo of beauty skyline

Camino en Belleza

Soy una Mariposa [Spanish]

+ Spanish Mariposa needed a ¼ extra page

I am a Butterfly [English]

+ English needed a ½ extra page

Photo of butterfly

Я бабочка! [Russian]

+ Russian needed 1½ extra pages

Je Suis un Papillon [French]

+ French needed ½ extra page

Só uma Borboleta! [Portuguesa]

+ Portuguesa needed 1 extra page

Photo of rainbow over red barn

Mi Amigo Felipe Ruiz

+ 8 lines of Ruiz's poem + Photo of Felipe's Rainbow

Mi Amor—El Viento

Photo of Fountain

My Lover the Wind!

Photo of Patriotic flags

Mira

Photo of purple sky

Mira Ja Been [español]

+ 3 lines of Mira Ja Been Español+ Photo of a Peach

Intro to English look at Ja Been

Look at Ja Been!

Photo of Pink rainbow

My Favorite Color Is Rainbow! [poem]

Photo of title rainbow

Photo of church rainbow

Noche Bella poem

+ 3 lines of poem + Photo of evening moon rising

Pebbles poem

Photo of Pebbles

Rainbow Drops

Intro to Sea Jewels

Sea Jewels poem

Photo Sea Jewels

Question for my sister Antonia

Photo of Black rainbow

Photo of 22nd street sunset

Serenity of the Spirit

+ ¼ pages of Serenity poem

Spring Lake poem

+ ¼ lines of Spring Lake poem,

Snow Fall

+ an ½ extra page of Snow Fall poem

Blank page

Snow War poem

+ 1 extra page of Snow War poem

Photo of I Hate Snow

Why I wrote this poem

+ 1 ½ pages of why I wrote this poem Snow War

Stone Cold Heart

Photo of stone cold heart

Photo of Stormy Dark Clouds

Intro About The Seed Poem

The Seed Poem

Photo of seeds

The Spangled Desert Sky Poem

+ 9 lines of + Photo of Spangled Sky

Intro to Terra

Terra Poem

+ ½ extra page of Terra poem

Photo to Terra

The Golden Green Time poem

The Golden Green Time photo

The People That Fly

Blank page

The Yarn Goes Round Poem

Picture of Yarn

Yucca lilies

The World Has Moved.

Sunday 19 April 1985 about 1 p.m. I am recalling the yard
of blue bonnet flowers I passed going home after
attending General Conference this Sunday on
Washington Street.

BLUE BONNETS

Spears of blue bonnets thrusting up
Like flames of bright blue natural gas.

They wave in yonder front yard as I pass
And give homage to our Almighty
in a humble way—

that we in our temples splendor—
cannot equal in wonder

Nature in such lowly flower, surpasses,
all the material wealth we are amassing.

And as I pass, I breathe a silent prayer—
"thank you, Lord for flowers fair."

01-1-1993 11:11 am

BEANS

I am washing these beans.
I look upon them—

I see my past.
Lowly pinto beans.
Not quite tasty as deer.

More time consuming
To cultivate, to gather,
clean, and cook them.

The bugs and the birds
Will try to eat them.

The strangers and even
your family will try
to take them before you.

But what you gather,
You can store—
And in the time

Of frost and snow
You can cook and consume,
The little lowly lonely beans.

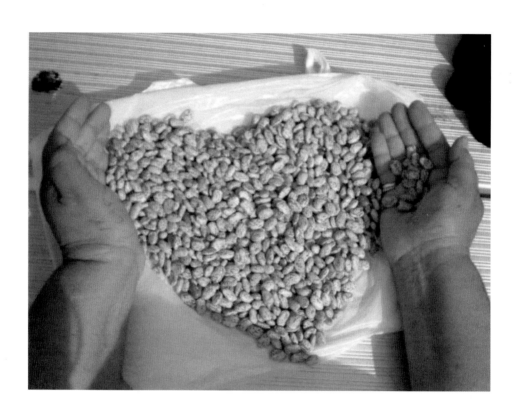

Later 11:28 am 01-01-1993

PINTO BEANS

My brown hands wash the speckled beans.
I think about myself and my family.

I see my present
As I wash the pinto beans.

Some beans are more
Brown than others. Some with more white showing.

My family is like that.
I married a white man.

I of the brown skin
And dark eyes.

My children are light skinned
And dark eyed.

My eldest son has a love wife—
Blonde with light eyes.

Will their children be dark
or light or pinto?

01011993 12pm

COOKED BEANS

As they cook,
the beans lose
their whiteness

and take on
a rusty, reddish, tone.

They lose their hardness,
and become soft, edible.

The Queen of England
was served refried beans
which she mistakenly
called 'used beans.'

En bola, meaning
whole boiled beans.
beans with some
crunch to them.

I liked them that way—
with Louisiana hot sauce,
black pepper, and salt—
rolled tightly in a tortilla.

But the most unusual was
the way my Mother
would serve us
when we were chopping cotton,

She would mash the beans
and swirl sour cream
or mayonnaise in.

01-17-1993 Sunday morning

Seeing a new calico cat newly born, My son Raymond was once attacked by a vicious German police dog while I was walking with him on his umbrella stroller in California. Raymond was barely 6 months old. I do not know how we survived the ordeal, but I managed somehow to to place my body in front of his and the dog and we escaped.

Raymond, however was traumatized and had a classic generalized fear of anything furry.

We gradually were able to re-introduce him to the animal world by letting him pet the ducks and cats which showed up in our back yard. This was just an alley cat, but it helped Raymie to become accustomed to our furred and feathered friends.

CALICO

KITTY CAT,

CALLI-CAT.

CALLY-KITTY CAT.

ALLEY CALLI,

CALLI-KITTY CAT.

KITTY ALLY CAT.

KITTY CATTY CALLI,

LITTLE ALLEY CAT.

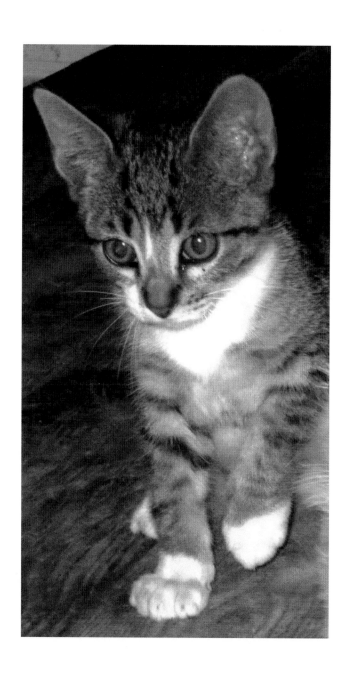

11 AM 11-16-1990 on the road to Monahans while delivering NDA.

CLOUD COVERLETS

I've seen the desert blanketed by clouds

with the sun piercing bright shafts

on one side--gray

on the other--a heart breaking blue.

The joy! As the sun shines

through--radiating the world

with its warmth for a few moments

before the wind once more kicks

up those soft snowy clouds and

lays a coverlet of clouds once more.

EL VALLE ESCONDIDO

18 March1997 written at 9:35 a.m. I am watching California on T.V. and in particular—the Torrey Pines on Sunday morning. Torrey Pines, San Diego, Topanga Canyon, L.A., Malibu Beach, Shasta Mountain, The great Valley of San Bernadino, The Sequoias, and the small dot of Thermal Town—all these places I have gathered into my heart and ingested, incorporated, inspired, into my sweet child—Raymond. In him I breathed into the very first smell of the nights honed with the fragrance of orange blossoms in miles of groves. Miles upon miles of the salty tang of the Pacific Sea—peaceful! It mimicked the motion of my full belly and then I found the perfect place to bring to light the fruit of my womb—El Valle Escondido—pero para mi—un valle perfecto pacifico, profundo, encantado—El Valle Escondido—a Hidden Valley.

4 June 2000

Dear Raymond –Son:

I wrote this a long time ago and wish I had given it to you then but then got distracted with other things in life. I know you deserve better and bless you for being who you are. I hope that I can take the high road and show you the better path. I know that you look to me to show that to you and I expected you to seek it on your own as I did. I did not always find it and probably might not have if I'd been lead—but it is not too late for you, Dear Son. Listen to my good council and don't wait on me to do good. Do good any way and choose the right.

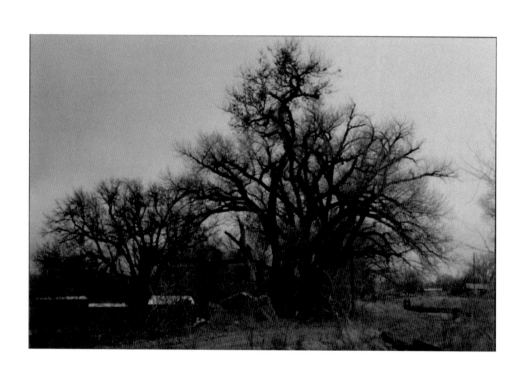

7 July 1995 9 pm. This poem is dedicated to Melvin Floyd Hailey, a dear friend who has the unhappy luck to think that he loves me from far off, Ft. Sumner, N.M. I had been returning from the Annual Hot Air Balloon Festival in Albuquerque, when I took the wrong turn off the freeway. As luck would have it I spied a wind generator in a front yard in front of a truck/car wash establishment and stopped to inquire as to the owner. Mr. Hailey was a most learned man.

HAILEY DAY IN FT. SUMNER

Today we drove down a dusty road,
In a dried up and blown-away town.

We stopped for gas at a self-serve
And a bubbly redhead gir we observed.

Shopped at a yard sale some one had,
Found a postage stamp-size gallery.

We drove up the creek just west of town,
To watch the dammed—up water cascade down.

Passed an old truck/car wash bay,
With a hydraulic wind driven pump.

Saw some friendly folks that first day
Building a storm shelter throwing dirt to clump.

Moseyed by Billy the kid's Museum.
Turned a tour by the Fort's ruin.

Saw the wild and the tamed,
But in the Valley the most beautiful of all—

Was an old gnarled ancient giant of a tree
Behind an abandoned old house.

The arboreal rose close to 50 feet or more,
drinking in the sky.

Its arms stretched out across the breast
Of the Earth and gave such shade.

At my feet it dropped a love offering,
A broken heart carved of it own flesh—

A seed to spring to life my love,
For this rough and rowdy Shangri-La!

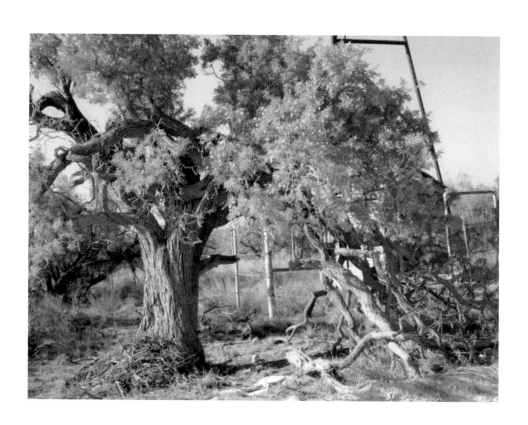

Burger night at stars drive inn

I LIVE ON A HILL

I live on a hill
on the slope of a rill—
where rainbows occur!

And the night daily
Sketches stretches of color
Across the skies!

Translated on 04 May 2002 at 1:08 am.

VIVO EN UNA LOMA

Vivo en una loma
en el tipo de ella

adonde ocurren arcos de iris
y la noche diario

escriben estrechos de color
sobre el cielo!

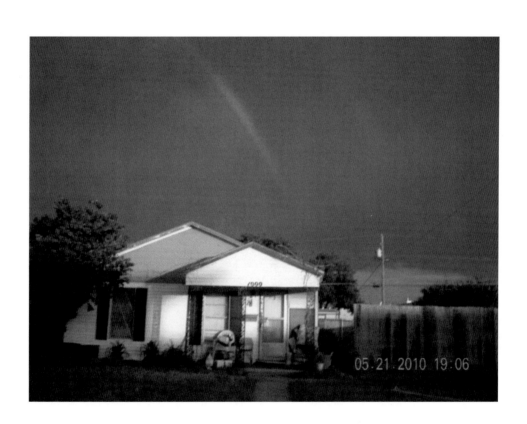

May 2002 8 a.m. This is dedicated to place out in the middle [literally]of nowhere--Peyote, TX, where I was working. Islas [meaning islands in Spanish] but it was a little garden spot--an oasis in the desert. I was inspired to write this poem.

ISLAS

Tu eres mi isla
Del deserto

Mi refugio y
Mi alegría.

Me refrescas
En el calor.

Me protejas
Del tempestea

Y me siento sana
En medio de ti.

ISLANDS

You are my oasis
In the desert.

My refuge
And my joy.

You refresh me
In the heat.

You protect me
from the tempest

and I feel safe
surrounded by you.

03-02-1993 @ 3 pm.

I WALK IN BEAUT Y

Where some see dusty horizons,
I see clean windswept vistas.

Where some decry the dryness,
I marvel at the sunshine.

Where some despite the barrenness,
I enjoy the fullness of my heart.

For I walk in beauty--
and the arc of the sky is my glory!

The lash of the lightening
as it thunders through the heavens

Thrills my soul.
For I see beaty.

And despite the bite
Of the sandstorm,

Or the chill of the blizzard--

I still fee, touch, and
Taste beauty!

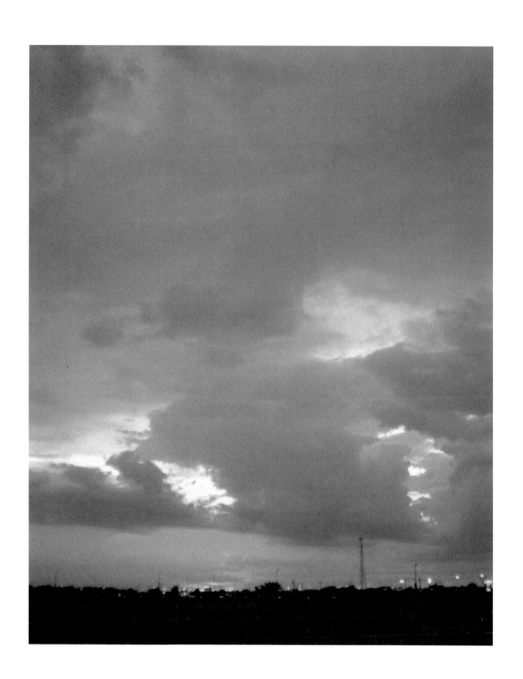

08-25-2005 @ 9:30 pm. Spanish translation

CAMINO EN BELLENZA

Donde unos critican el seco
Me maravillo en el sol.

Donde unos se desgastan el despolvado
Gozo de la plena de mi corazón.

Porque yo camino en belleza--
Y el arco del cielo

¡es mi gloria!
Y el azorte del relámpago

Cuando camina por los cielos
Éxtasis mi alma

Porque yo veo belleza
Y a pesar de picotazo

De la tormenta arenosa,
o la mordida del granizo fría--

siempre me siento, toco, y
gozo- ¡belle!

SOY UNA MARIPOSA

A un tiempo nací en un cuerpo muy pequeño y arrugado. Crecí y crecí después no pude contenerme en esta piel. Dormí por un tiempo enredada entre una tumba profunda. Después soñé que oia [escuchaba] canciones y veía luz, que sentía calor y después un frio y oscuridad de la muerte.

Primero me movía poquito, después más. Sentí una comezón y tuve que recolarme otra vez; empujé mi cuerpo contra la cascara que me contenía de repente salió un brazo y des pues el otro.

Me deslice fuertemente y con un gran esfuerzo, libre mi cabeza y mis ojos pudieron ver la luz del dia y los colores que me esperaban. Escuche y oi todas las cosas como antes, pero ahora con nuevo sentido--todo mas brillante--con mas profundidad. Y decide compartir todo deshaciéndome de este csco, el que siempre me impresionaba; ¡Sali completamente libre!

Por un tiempo tremble y descanse de la freza de salir, y gradualmente con mucho temor me pare sobre mis pies y me enderece; repire profundamente perciendo los grandes olores y observando todos los varios colores. Me dio por extener mis brazos y escuche mas que sendi--un sonidio cujido. Voltee y vi--una ala de colores fantasticos ¿Cómo era esto?

Voltee al otro lado y alli estba otra alla.encantda, las movi sacudiendolas y me levantaron un poquito. Haci mas esfuerzos y subi sobre la faz de la tierra. Que bells,que gusto, que gozo--me habia cambiadido de un guzano y una maravillosa--¡mariposa!

I AM A BUTTERFLY

I was once born in a small and wrinkled body. I grew and grew and then, I couldn't contain myself in this in this skin. I slept for a time wrapped in a deep tomb. Then I dreamed that I heard songs and saw light, that I felt warmth and a chill and darkness I like death.

First, I moved a little, and then more. I felt a tickling and had to relocate myself again. I pushed my body against the casing that contained me and suddenly--a limb came out and then the other.

I struggled greatly and with a great force, I freed my head, and my eyes were able to see the light of day and the colors, which were waiting for me. I listened and heard all the things as before, but now with a new sensitivity--more brilliant--more profound. And I decided to enjoy everything throwing off this casting, which always had imprisoned me; I came out completely free!

For a time, I trembled and rested from the effort of coming out, and gradually with much timidness, I stood on my feet and straightened up; took a deep breath, perceiving the great smells and observing all the various colors. I thought to extend my limbs and heard more than felt--a crackling sound. I turned and saw--a wing of fantastic colors. How is this possible? I turned on the other side and there was another wing. Enchanted I shook them, and they lifted me a little.

I made a little more effort, and I rose over the Earth and a breeze lifted me up and took me. I flew over the face of

the Earth. How beautiful, how wonderful, what happiness, what joy--I had changed from a worm and marvelously into a butterfly

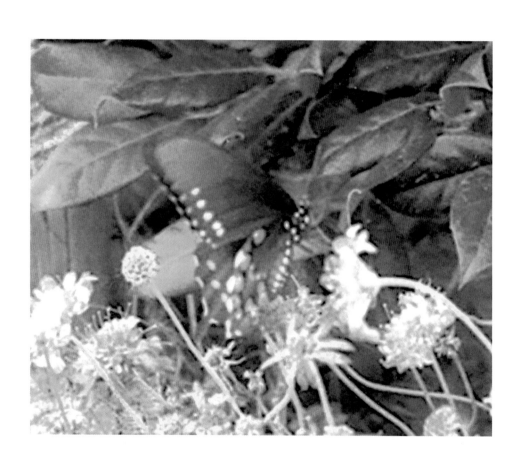

Я БАБОЧКА

Однажды я родилась в маленьком и морщинистом теле. Я росла и росла, и никак не могла сдержать себя в этой коже. Заключенная в темной гробнице я немного спала. И потом мне приснилось, что слышу песни и вижу свет, чувствую тепло, но потом пришел холод и смертельная тьма.

Я начала немного двигаться, потом еще немного... Почувствовала щекотку и снова начала двигаться. Я начала выталкивать себя из оболочки, в которой находилась, и вдруг одна конечность вышла, а затем другая.

Я приложила больше усилий и высвободила голову, теперь мои глаза увидели свет дня и цвета, которые ожидали меня. Я слушала и слышала все, как и раньше, но теперь это было с новой остротой - более яркой, более глубокой. И я поняла, что хочу наслаждаться всем этим, что мне нужно сбросить этот кожух, который заключил меня в тюрьму! И вдруг я вышла, и стала абсолютно свободной!

Недолго я дрожала и пыталась отдохнуть, поскольку попытки вырваться из кокона истощили меня, но затем, со страхом и робостью я встала на ноги и выпрямилась; Я глубоко вздохнула, вдыхая запахи и любуясь цветами. Я решала вытянуть свои конечности, и услышала больше, чем почувствовала - треск. Я обернулась и увидела крыло с фантастическими цветами. Возможно ли это? Я посмотрела в другую сторону, и обнаружила там другое крыло. Зачарованная, я встряхнула ними, и они немного подняли меня.

Я приложила еще немного усилий, и поднялась над Землей, небольшой ветерок закружил меня и понес. Я полетела над землей.

Как прекрасно, как чудесно, какое счастье, какая радость - из червяка
я чудесным образом превратилась в бабочку!

Tue 4/30/2019 5:29 PM Butterfly translated into Russian
by my friend Natalia Kalm.

JE SUIS UN PAPILLON

Je suis née dans un petit corps ride. J'ai grandi et grandi, jusqu'à ce que je ne pouvait pas me contenir dans cette peau. J'ai dormi un moment, enveloppe dans un tombeau profond. Puis, j'ai rêve que j'ai entendu les chansons et j'ai vu la lumière. J'ai senti de la chaleur et puis un frisson et une obscurité comme la mort.

Premier, j'ai bouge un peu, et puis un peu plus. J'ai senti un chatouillement et j'ai dû me déménage encore. Je me suis pousse contre l'enveloppe que m'a contenu. Tout à coup, un membre est sorti et puis l'autre.

J'ai beaucoup lutte et avec une grande force, je me suis libère la tête, et les yeux pouvaient voir la lumière du jour et des couleurs. J'ai écouté et j'ai tout entendu avec une nouvelle sensibilité - plus brillant, plus profond. J'ai décidé d'apprécier tout, j'ai jeté ce boitier qui m'avait toujours emprisonné. Je suis sorti complètement libre !

Pendant un temps j'ai tremble et je me suis repose de l'effort de sortir, et progressivement et très timide, je me suis levé et je me suis redresse ; je pris une profonde inspiration, observe toutes les odeurs et les couleurs. Je

pensais étendre mes membres, et j'ai entendu un craquement. Je me suis retourne et j'ai vu - une aile de couleurs fantastique. Comment est-ce possible ? Je me suis retourne de l'autre cote et il y avait une autre aile. Enchante, je les ai secoués et ils m'ont soulevé un peu. J'ai fait un peu plus d'effort et je suis monte au-dessus de la terre, et une brise m'a soulevé !

J'ai survole la surface de la terre. Si beau, c'est merveilleux ! Quel bonheur ! Quelle joie !

Je suis passe d'un ver a un papillon merveilleux. !

04292022 Butterfly Translated Into French By My Friend Emily Martin.

SÓ UMA BORBOLETA

Eu nasci uma vez em um corpo peguento e enrugado.

Nasci e nasci e então, eu não pude conter eu mesmo

nesta pele. Eu dormi por um tempo embrulhado em uma

tumba profunda. Então eu sonhei que ouvi canções e vi

luz, que eu senti calor e então um calafrio e escuridão

como a morte.

Primeiro eu mudei um pouco, e então mais. Senti

cócegas e tive que mudar eu mesmo novamente. Eu

empurrei meu corpo contra a cobertura que me continha

e de repente -- um membro saiu e então o outro.

Eu lutei muito e com uma grande força, libertei minha

cabeça e meus olhos foram capazes de ver a luz do dia e

essas cores, que estavam me esperando. Escutei e ouvi

todas as coisas como antes, mas agora com uma nova

sensibilidade -- mais brilhantes -- mais profundas. E eu

decidi aproveitar tudo jogando fora essa cobertura, que sempre me aprisionou; eu saí completamente libertada.

Por um tempo eu tremi e descansei do esforço de sair, e gradualmente com muita timidez, fiquei de pé e me endireitei; eu respirei fundo percebendo os grandes cheiros e observando todas as grandes cores. Pensei ampliar meus membros e ouvi mais do que senti -- um som crepitante.

Eu virei e vi -- uma asa de cores fantásticas. Como isso é possível? Eu liguei para o outo lado e havia outra asa. Encantada eu as sacudi e elas me levantaram um pouco. Fiz um pouco mais de esforço, e me levantei acima da terra e uma brisa me levantou e me levou. Eu voei sobre a face da terra. Que bonita, que maravilhosa, que felicidade, que alegria -- eu havia mudado de um verme e maravilhosamente em uma -- borboleta!

11042019 Butterfly translated into Portuguese by my friend Christy

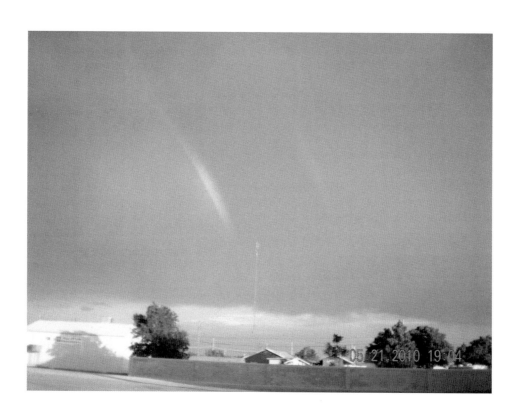

03182007

MI AMIGO FELIPE RUIZ

Que lindo son los sonidos de tu piano.
Como tu corazón
Me inspiran
A mi alma hacer poemas.
Gracias Amigo
Por compartir
Tu arte conmigo.

Yo se que soy muy brusca
Y no conozco la mil parte de
La dificultada que riqueza
Tu práctica.

Pero si puedo admirar
Las danzas y los cantos
Que me has permitido
Saber de ti

Y gozare recordando
Tu lindo ser.
Las guardare en me
Como la perfume de
Flores en primavera.

En este Otón de mi vida
Me has presentado con
Bellas artes y no me
Has negado el calor
De tu mente.

Y con estas pocas palabras
Quero que te recuerdas de mí.
Que por un rarito bale con
Tu música y murmura con
Tus canciones.

Gracias Amigo Felipe Ruiz.

De tu Amiga Teresa Waters

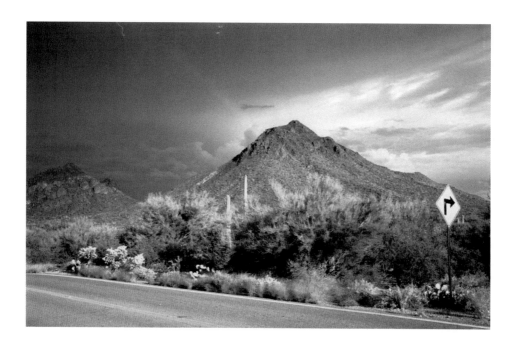

Mientras que estoy afuera regando mis plantas y árboles. No quiero regresar entre la casa calurosamente--la cual no tiene condición de aire. Una tormenta menas por el sur este. Relámpagos de calor brillar sobre las nueves. El viento se enfureza y me refresca.

¡MI AMOR—EL VIENTO!

El viento es mi amante
Y yo soy el del.

Me abraza en ataques de ráfagas
Me acaricia con

Un suspiro sobre mis mejillas
Corre sus ventosos dedos
Por mi largo pelo negro

Y me habla palabras
De amor con respiros de alma.

Mi amor me trae lluvia
Y me sopla nubes frescas

Para aliviar mi frente.
Pone hojuelas cristalinas de la nieve
En mi nariz y adorna

Mi cabeza con un corona
de hojas Otoñas.

Trae lluvias suaves para
Regar mi jardín y
llena mi fuente para tomar

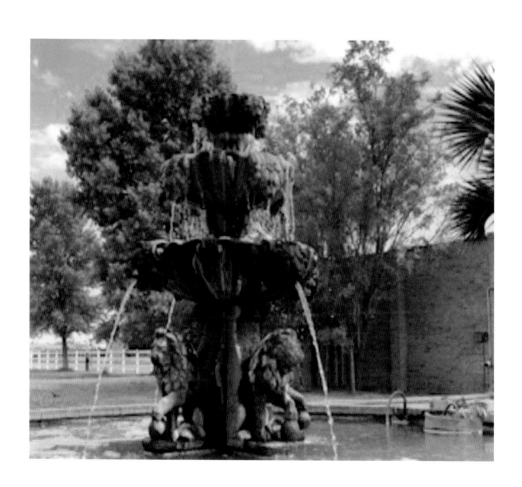

15-May-1993 9:30 p.m. © While outside after watering my plants and trees, I feel reluctant to return into the hot un-air-conditioned house. A thunderstorm is brewing toward the southeast. Heat lightening flashes sporadically amongst the thunderheads. The wind freshens and r efreshes me.

MY LOVER--THE WIND!

The wind is my lover,
and I am his.

He embraces me in fits of gusts.
He caresses me with
a sigh across my cheek.

He runs his windy fingers
through my long black hair.

and speaks to me words
of love with a soulful moan.

My lover brings me rain
and blows cool clouds
to soothe my tired brow.

He lays crystal snowflakes
on my nose and adorns
my head with a crown
of autumn leaves.

He brings gentle rains
to water my garden and
fill my fountain for drink.

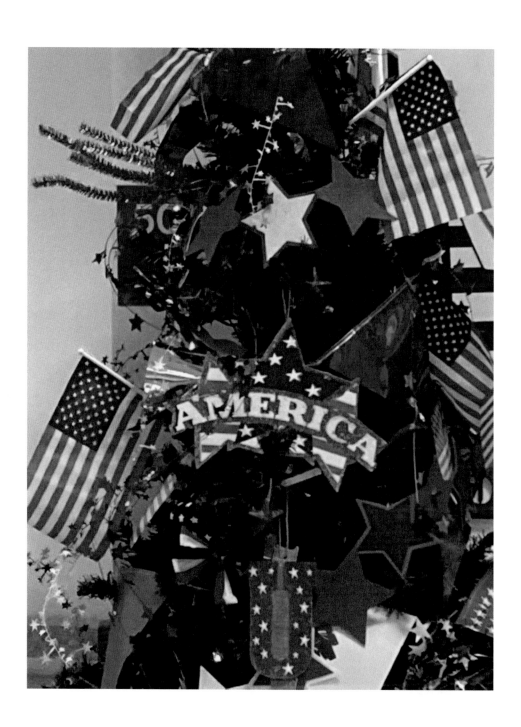

MIRA

Que lindo son los cielos
cuando esta bajando el sol!

Colores de rosa, azules,
turquesa, morados, y oro.

En este plano
del deserto--

no nesecitamos
montanas, ne lagos

para gusar de
la abundancia

y esplendor o
 la majestidad--
de vostros vistas.

April/Spring sometime in1993

MIRA JA BEEN

Mira—Ja Been!
Su pelo tan negro
Como la ala de un ave.

Su risa se ensena
Un rollo de perlas.

La pel desta mujer
Es como el color de
Un durazno.

¡Sus ojos negros son
Como la noche profunda!
Y ha recibiendo todo—
No es nada sin su
inteligencia.

Aquela chispa de mente
La qual se viste

Su genio la qual sin

Es no mas varo—una

vessija—vasilla!

English version was translated at 9:40 p.m. The poem is dedicated to a lovely Muslim woman whom I met when I went to purchase office supplies. I asked to take her photograph for she was a true vision of loveliness, but she refused stating that she was a daughter of the Prophet. I needed to record for history the breathtaking beauty of the woman and so I was inspired to write this poem in her honor--the which I wish all Muslim women could be the example—intelligent, bold without being outrageous—not mincing a good Woman may <u>Allat </u>be praised

LOOK AT—JA BEEN!

Look at—Ja Been!
Her hair the black wing of a
Raven.

Her smile displays
A row of pearls.

The skin of this woman
Is the tone of a peach.

Her black eyes are
Like the night—so deep!

And yet—taking in
everything—
All is nothing without
Her intelligence!

That spark of mind
Of which Her genius is
clothed

And the which--without
She is merely muddy
matter—
An empty vessel—vassal

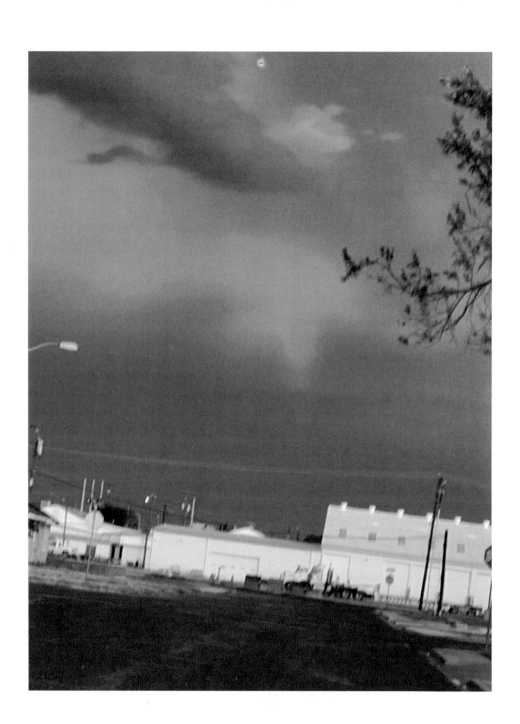

29 August 1986 at 4 a.m.

MY FAVORITE COLOR IS...RAINBOW!

My children would often ponder—

What is your favorite tone—I wonder?

Is it a brightly red or blue?

Or some other paisley pastel hue?

To their constant question I'd think

Should I choose a green or pink?

All the colors seem equally fair,

Which to choose as oh—so rare?

To the sky I looked both high and low

And said, "My favorite color is...Rainbow!"

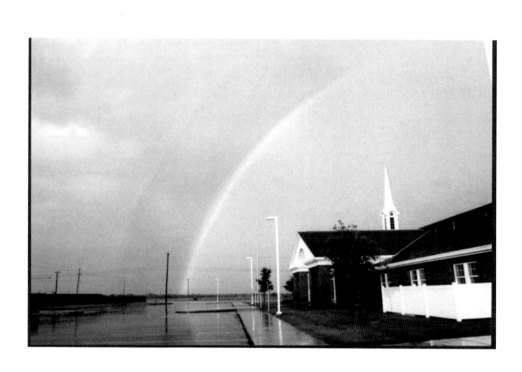

8-7-1995 9:45 p.m.

NOCHE BELLA

I go outside for a breath of air.
To cool my heated brow.
There is a breeze afuera—
It draws me out.

I timidly, gingerly, step out
Without shoes--so my steps are limited.

My eyes rise heavenward
Seeking the beauty of
las estrellas--the stars.

The deepness of the Midnight
Blue is contrasted against
The cobblestone patches of clouds.

I walk eastward—toward the
Light and behold the
Bright splendor of the Moon.

O Luna—Linda y eterna!
Como luzas a mi Alma!

The deep shadows and the
bright lighted sides of Lamar
Act as an Artist's background.

An Artistic focal point
A Human artificial artifact.

Against the eternal setting
Of these Southern Summer Skies
Los cielos del sur

PEBBLES

What pebbles of my life
Can I gather for you, Dear Friend,
To explain what it has been like?

These small and uneventful stones
Which mark an experience or event?

Sunbleached and dry, they seem
Unremarkable, and yet—

When wetted by the illumination
Of memory—they sparkle and shine?

Tugged by the tides of time
These hoary rocks impound my heart

And I have suffered the isolation
To prevent the hurts hurled at my heart

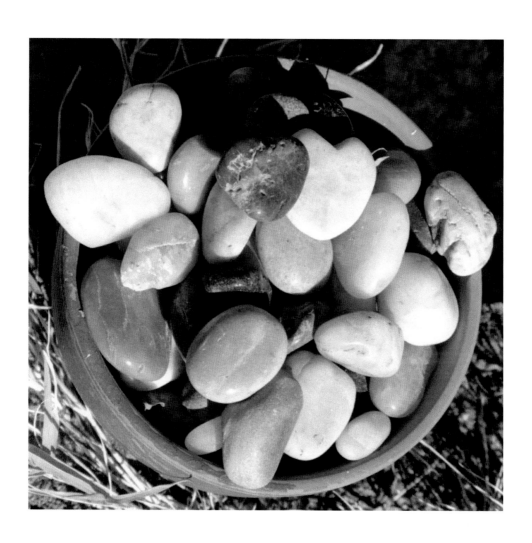

RAINBOW DROPS

When you are sad,
When you've been bad.

When the whole world
Seems to press you down,

Twirl the magic crystal ball
And make it whirl around.

Reds, oranges, yellows,
greens, and blues,

Each and every color
comes shining through.

In each tiny spot of light,
Is a beauty to make things right.

11 August 1991 12 p.m.

I would take my children to Padre Island when they were young for a two week vacation on the beach. I decided to buy some beautiful sea shells while I was in town. As we were returning to our campground, I saw a orange color carton the size of a hand on the sand. As I reached to examine it, I saw that it was a carton with the words "sea jewels". I quickly arranged my cache of sea shells and took photos. I later had the inspiration for this poem at church & dedicated to Alyne Fuller who gave me the pen & paper to write it down

11 August 1991 12 pm

SEA JEWELS

I walked down
The beach one day,

And found some simple shells
Along the way.

I stopped and gazed at
The fine array…

At Nature's example of
The Sea's castaway.

As a pearl in an
Oyster is formed;

From a poor creature's
Misery to a lovely Jewel.

So, a saved soul from
A sinner's plight—

Humanity's wretched
can become—

A shinning example
 of God's second sight.

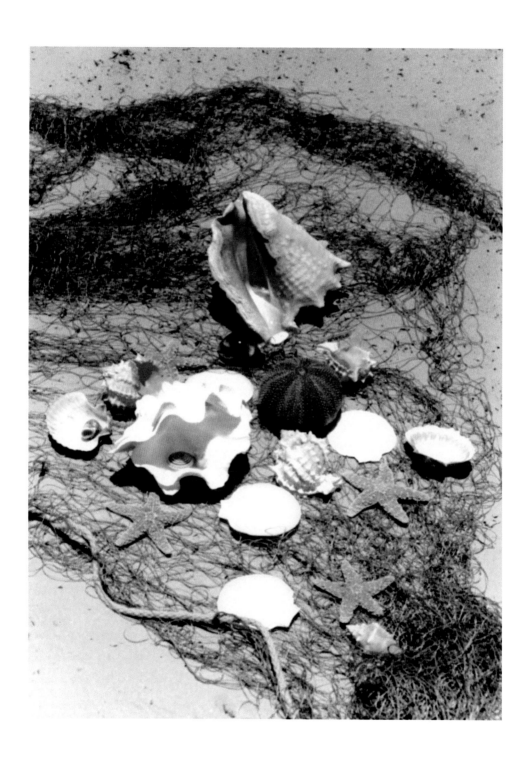

1-1-1993 11 a.m.

After talking to my sister, Antonia,[in San Jose, California] over the phone.

Am I a poet because I decide to write down these feelings of intense pain, joy and of being? Or am I a poet because feel like one? I don't know. I merely know that I must, and like an addict, I am compelled to do so. Life is so keenly drawn out for me. My life is like a sharp blade. I can not rest on the soft sides. I must constantly be on point. To others, my life might seem dull, but they have no contact with me and when they do, they find that poignant quality often times too much--veering quickly from my association-- because to truly know me is too concentrated a feeling.

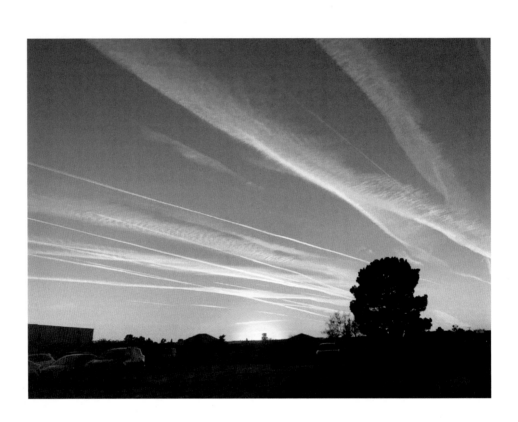

6-12-1992 on my way to Taos, New Mexico, 2 p.m

SERENITY OF THE SPIRIT

Serenity of the spirit...
a feast for the soul.

Solitude--not loneliness.

A quietness of being.
not anxiety, but
peace---blissfulness

not desolation, but a
resolution to be set free--
of ant-like activities.

A certain amount of money buys
this precious liberty.
I will snatch it up...

like a famished
starving Somalian
consuming a long
awaited needed meal.

A renewal of self--
so I can continue the
outpouring of my unselfishness
to my family.

6-12-1992 5:30 p.m. on my way To Taos, New
Mexico.

SPRING LAKE

Sheep grazing in the pastures,
 amongst the rows.
the same color as their fodder.

A dead badger
killed on the side of the road.

Snow on the western
embankment hidden
 from the southern sun.

The rusty red earth.
Her breast rent bare
to the ravages of the elements.

11292001 8:39 am. I am looking at the snow' which has accumulated after our first snowstorm of the year [

SNOW FALL

The sun shines upon
the hillocks of drifted snow,

which sparkle with
 a crystallized crust,

marked here and there
with tiny tracks of sparrow's feet,
that have braved the cold

to seek sunken seeds.
In the shadows,

the snow is blued,
Whilst in the sun—

it is rosed
to a lovely mauve.

The snow,
where banked

against the fences,
lies deep and undisturbed,

even as the sun
has begun an assault

to return the element
back to heaven.

I watch the ice
slowly melting

against the glass
as it serenely slides
down the outside.

The inside is not
much warmer

as I sit on the
opposite side

of the patio glass
sliding door.

February 10 1985 written at home when we had a true Texas blizzard.

SNOW WAR

Tiny blossoms of cold,

minute rosettes of snow.

falling, falling from on high.

They are whipped by the wind

melted by the warm drafts.

From on high they are launched,

like vicious little warriors

against—*warmth!*

--floating, falling—ever falling

in their parachutes of lacy ice.

At first, *billions* die

on the warm breast

of the unburdened Earth—

disintegrated—

by the benign rays

of trapped heat.
But as each dies
the snow drop leaves
its legacy in *cold*—

A frozen puddle
of icy blood—

Spreading a chilly film
onto the unsuspecting dirt.

And the onslaught
continues…

Until the soft, tender breast
of the Earth is frozen—

Foamed in icy white,
yet mercifully covering
her ravish form—

by the falling, falling,
ever--falling, <u>snow.</u>

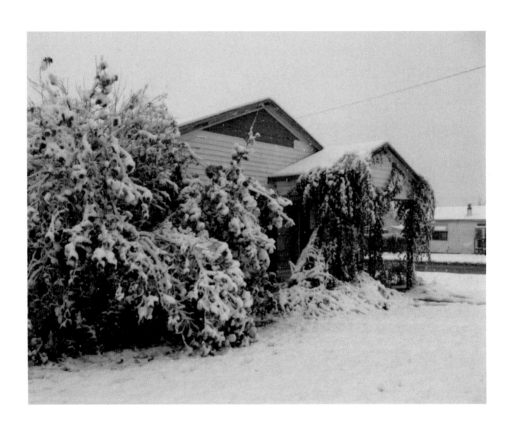

We had no where to go and there was snow

falling—coming up to about two feet of snow. It

was piling up between the old wooden crate fence*

and the east side of the house. I hate cold—I hate

snow—because of the consequences: illness,

colds, pneumonia, high-energy bills, and the feeling

of never being warm. But on this day—Saturday, I

could snuggle into bed with no chores, no duties,

and no job to go to. As I watched--the snow

dropped against the windowpanes. Artistically

inclined, though I hate cold—yet I am compelled to

capture the awesome image in some form--—and

so this poem.

* (I had build the wooden fence out of the material which

had been the shipping boxes of the air conditioners that

the Parkis company had installed at Lamar Elementary

School across from my house.) I recall a time while I was

working as a carpenter for Parkis, uncrating the air

conditioners, and I was climbing one of their two-story aluminum ladders and somehow the hook, which keeps the ladder onto the roof had extended gave way. My head had just cleared the top of the roof and somehow as the ladder slid sickenly down toward the ground I was miraculously lifted up on top of the graveled surface of the roof. From that moment on I believed in Angels—I know that my guardian Angel was on duty and saved me from a very dangerous fall and saved me for my children.

++Here I should tell of the importance of this poem. I had a nice collection of my personal artworks—many in pencil, pen, and charcoals. Some were even in colored pastels and oils as well as a couple of shaved plasters and one bronze statuette which I modeled after my husband Raymond. [That sculpture is called:
"Atlas Fallen", because Ray had so disillusioned me, and had all the cares of the world when he committed suicide].

All my belongings and my collection of over a thousand books were destroyed in a house fire. Luckily my mother was all right, but it devastated me. I went into an artistic shock—not able to paint or sketch for years. I believe it was for almost 5 years. And then I saw these snow flakes and my spirit began to thaw. Afterwards, I began to write more poetry and thought—wouldn't it be nice to have a picture with each poem? And that is how I began my photography.

STONE COLD HEART

I walk outside to view the dusting of snow on the ground. It looks like a baker has sprinkled confectioner's sugar all around.

As I step across the caliche drive to the mailbox on the street, I look down to carefully place my feet on a path I always cross.

There in the cloud light of the winter afternoon I see the snow has outlined a rock. It registers in my reptilian brain—but I step over it and retrieve my mail. Serendipitously, as I turn to go home, I see it more clearly-- a Stone Cold Heart.

[Also, serendipity, I had my little Nikon Coolpix digital camera in my pocket and took the picture. It looked beautiful, but unfortunately since I dropped the camera about a few months ago, it doesn't always store the photos. When I went to review the picture, I found it later in a different file.

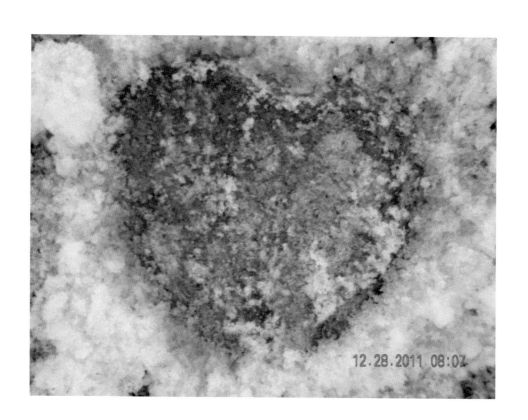

12.28.2011 08:07

12-17-1993 9:17 a.m.

Thinking about the video "Legacy of Central America,"
and the other great poets of Popo Val in Mexico's pre-
Columbian history. I have often thought of my struggles
against oppression and discrimination and considered
myself to be a 'human plow.' But I never did like that term
even though I gave myself that, because of the image of
tearing and breaking Mother Earth. Today I have thought
of something else…and have brought

THE SEED

I am a seed,

which is planted deep in the Earth.

I struggle against great odds

And hard obstacles.

I take my nourishment from the Earth.

My roots are firmly planted here!

My mind reaches out toward the Light.

That kernel—eternal; made carnal.

I gather the things of the Earth

And from it make

A new life--fraternal.

The cycle returns again to the

Beginning—a seed!

23 Mar 1989 ©, 8 pm in front porch at home.

THE SPANGLED DESERT SKY

Oh such spangled colors spread--
across the bosom of my desert sky!

An angry black storm cloud,
be-speckled with various colors
of shimmering golds and yellows.

These intrude upon a field

of utter blue turquoise.
This then fades
into a rosy splendor

fetched with mauve
and jaded limes.

These skies!
Oh! *This* sky--
which wrenches

my very heart's
soul-- and makes

me long for home
when I'm away.

No craggy mountain
nor roguish river
can claim my heart.

No ocean
or forest hold me sway.

Each moment
 brings a new and
wondrous change

upon the face of heaven.
Oh, Goddess!
how you entreat me

how you change and yet--
remain so--dear.

Every moment
a new configuration

of clouds and colors
in this, the end of day

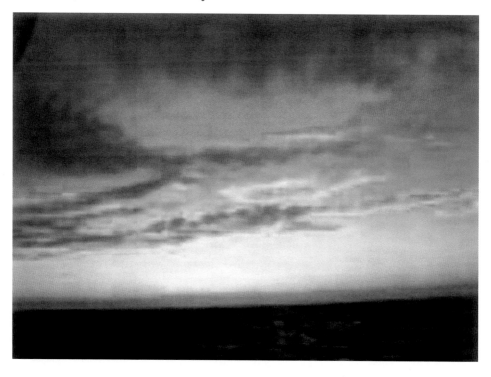

15 December 1994 6:30 A.M.

I am thinking of making a black earthen Native American pot. It has been about two years, now, for two Grandmother Seasons have passed. I could not make the gift which I had promised her--it was not time. But it will soon be time, because now I have the poem. The vision came early, but the poem did not. Sometimes we need to visualize an idea, vocalize it, (the word to become flesh) to materialize it to make mind into matter

TERRA

I take thee Earth,
from the Center of the Earth.

I take thee Earth,
to make a center.

In the earth is my Center.
the center is my Earth.

I am in the Center.
I will return to the Center.

I will make a center in the earth.
This Center I will make from the Earth.

Great Mother--of Thee I am born.
To Thee I will return.
For my people of Terra
to make a center.

In the earth is my Center.
The center is my Earth.

I am in the Center.

I will return to the Center.

I will make a center in the Earth.

This Center I will make from the Earth.

Great Mother--of Thee I am born.

To Thee I will return.

May my Earth become a Center

For my people of Terra.

2-20-1995 11 A.M. at home I had thought of this phenomenon about this golden-green light, but had never sat down to write it before. As a precaution against my accidentally forgetting it, I tacked it onto the tail-end of the poem I wrote in March 1989. I feel this is an eternal period of the day--one in which I can see the past and the future and enjoy the present.

THE GOLDEN-GREEN TIME

At the end of the day

when the earth stills

and the wind calms

there comes a time

of quietness.

The sun light slants

across the horizon

in shafts of golden light

painting everything

in golden splendor

while bouncing off

the green grass

of the earth

giving the whole

a golden-green glow.

Written circa 1985 I had to fly on an airline plane

THE PEOPLE THAT FLY

What arrogance! To presume to be lords
not only of creation but also of the _skies!_
to fly—to be able to launch
an entire nation into the air.

This then, describes the Americans.
So, is it any surprise when they view the
crashing of one of their jetliners
as such a tragedy?

The cream fly the planes
while the poor peasants
still crawl about on
the scum of the earth.

Such arrogance! To be able to view
all the world from the stratus,
knowing that it all can be had—
for a price of course!

Creatures of habit—the fly boys
shuttle their airborne buses
and the cities become
merely points---on a map.

So the step on the moon was
not such a large one.
For most Americans, are anxiously awaiting
to be able to ski on the slopes—
of the Moon!

Question for my sister Antonia

YARN

Ruedas de hilos unidos en nudos

Etas palabras se caen de mi mente feverente.

Se unen en ruedas de hilos unidos en nudos.

Estoy afuera acompañad de las estrellas y planetas

De marso y del lucero venus.

El vento me carisea con el sonido del ganso.

Las cascadas de la chicharra me cantan constantemente.

Me da el olor del barro mojado des de mi tierra.

the words of the poem go around the yarn and the

1-10-1991

THE WORLD HAS MOVED

The world has moved beneath my feet

And I am further off from home.

The more I travel away, it seems,

The more I roam.

How can I ever once again,

Return to the places in my heart...

If, as the world turns,

I move away, with

Only successive approximations

Of being almost home...

But never quite the same.

2 June 1990 This is dedicated to Laurel Vore who helped me get over some pumice rocks. © Teresa Waters

TURQUOISE IN GRANITE

The pressures of life
Squeeze—even the life's blood
—from a rock!

It bubbles out and when cooled,
Pools into a smooth surface—
A liquid blue tear.

The grey cloudy evening is mellowed
By the blue break in the bleak bellows—

Like turquoise in granite
Something beautiful in a rough matrix.

Happiness may not always be constant,
But can be concentrated—

Distilled and refined—
So that the memory lingers

Past the cheerful time.
And I can draw upon
The thoughts embedded

Deep within grey matter
To examine once more—
The gems of my mind=mine.

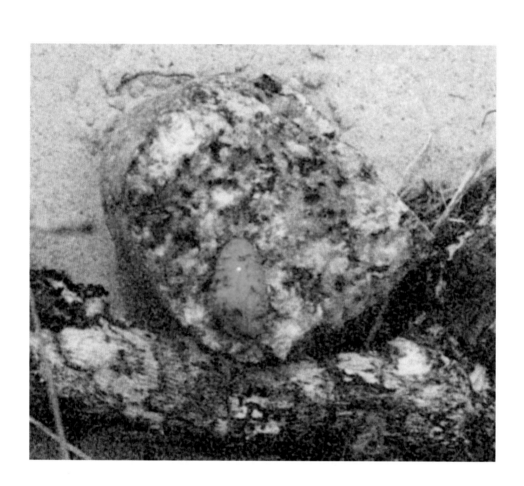

23 Sept. 1990 12:10 P.M. in church.

A UNIVERSAL BEING

I am a universal being

in tune with the elements;

swayed by the cosmos.

The rivers of stars

flow in my veins,

and the blood of plasma

energy quickens me.

The depth of Space

is in my soul and

Eternity on my mind.

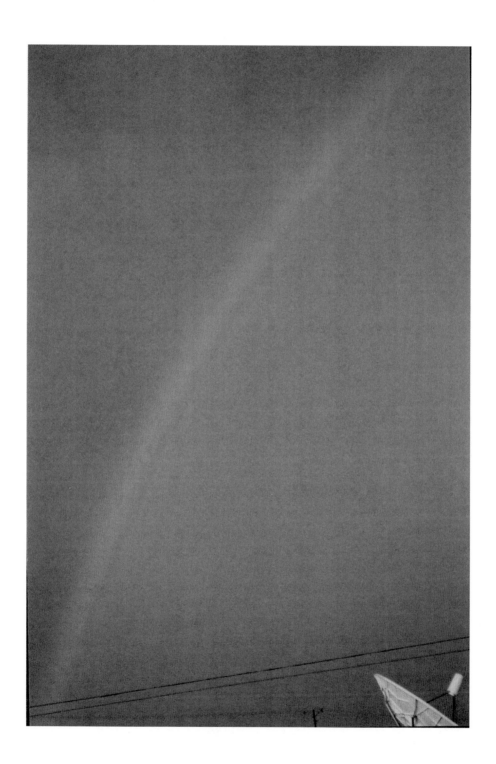

8 April 2002 ©

WATER

I am like a babbling brook that courses over mountain boulders.

Skipping up and down the rocks of life

Slipping over the gravelly places and the rough spots.

Washing through the easy spaces and

Meandering around those troubled ones.

Take me, use me, but don't abuse me.

Let me be a part of you, if you will,

or just allow me freedom to pass you by.

I am water, cool at times, raging at others.

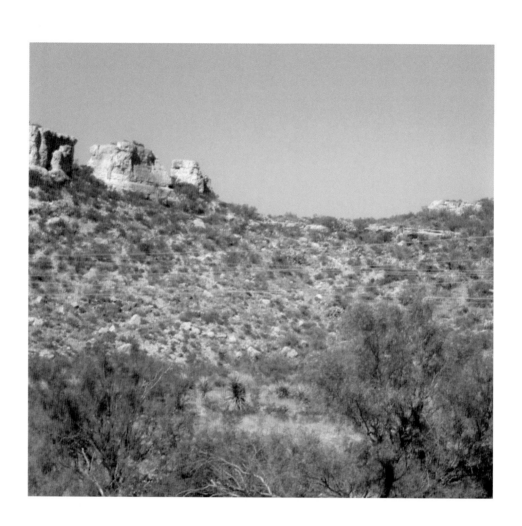

Sunday June 18, 1983 at 10 a.m. This next poem was composed during a Sacrament meeting after our home was destroyed by fire. A lady who was playing the organ was wearing a black and white striped dress. As I separated mind from matter, I remembered the pencil sketch I had drawn of a baby zebra's head in front of its mothers' body (I had sketched it from a newspaper clipping). The beautiful yellow daffodils someone had placed near the pulpit kept interfacing in this complex vision and started the inspiration for this poem. I usually slept during sacrament because of having to over work in order to keep my little family and mother together.

ZEBRAS AND DAFFODILS

Black and white—stripes
parallels in line.

Zags and zips—zip
through backgrounds.

Shadows of light
and shades of shine,

Permeate a panorama
of—bland.

While shades of sunshine
brightly—bold!

Beckon though stems
of daffodils.

03 3 2010 09:57

The author

Teresa S. Waters is a gentlewoman, artist, and a scholar. She is a poet, engages in most forms of art, visual art, photography, film documentaries, computer graphics, [her poster having been accepted to the Siggraph 2007]. Ms. Waters is well read on many subjects of which most sciences are her favorites. She can speak both English and Spanish and enjoys learning to say: "Thank you," in other languages. She is past Art Director of the Odessa Hispanic Chamber of Commerce, President of Texas Talents, Life long member of the Friends of the Ector County Library, Permian Basin Poetry Society, and is active in many community service organizations.

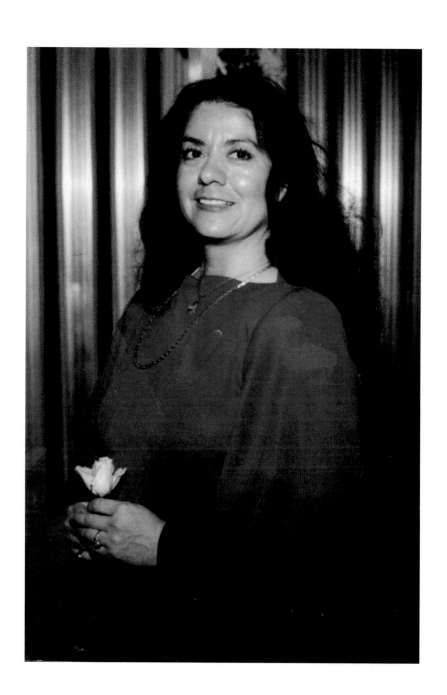

Made in the USA
Coppell, TX
01 November 2023